# The Occult
## Colouring Book

20 intricate and original illustrations by
## DS Blake

ISBN 978-1-326-50575-2
90000

9 781326 505752

**FIRST EDITION** 2015

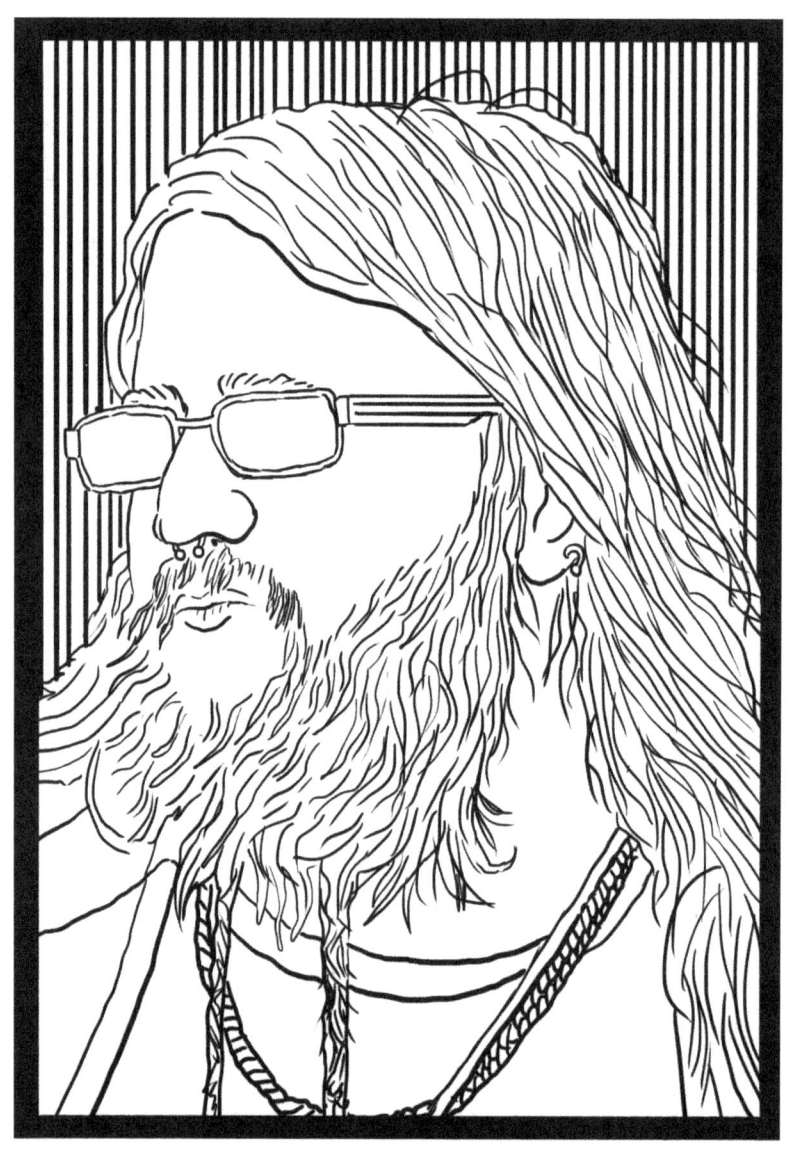

With thanks to N for their support

**Please Note:** Each image has a blank spread seperating it from each other image. This is to allow you to use pens and other colouring media that might bleed through or smudge without having to worry about damaging other images. Extra pages were also necessary for technical reasons in order to be able to provide a good quality, durable binding at a size appropriate to the images. No pages are missing from this book.

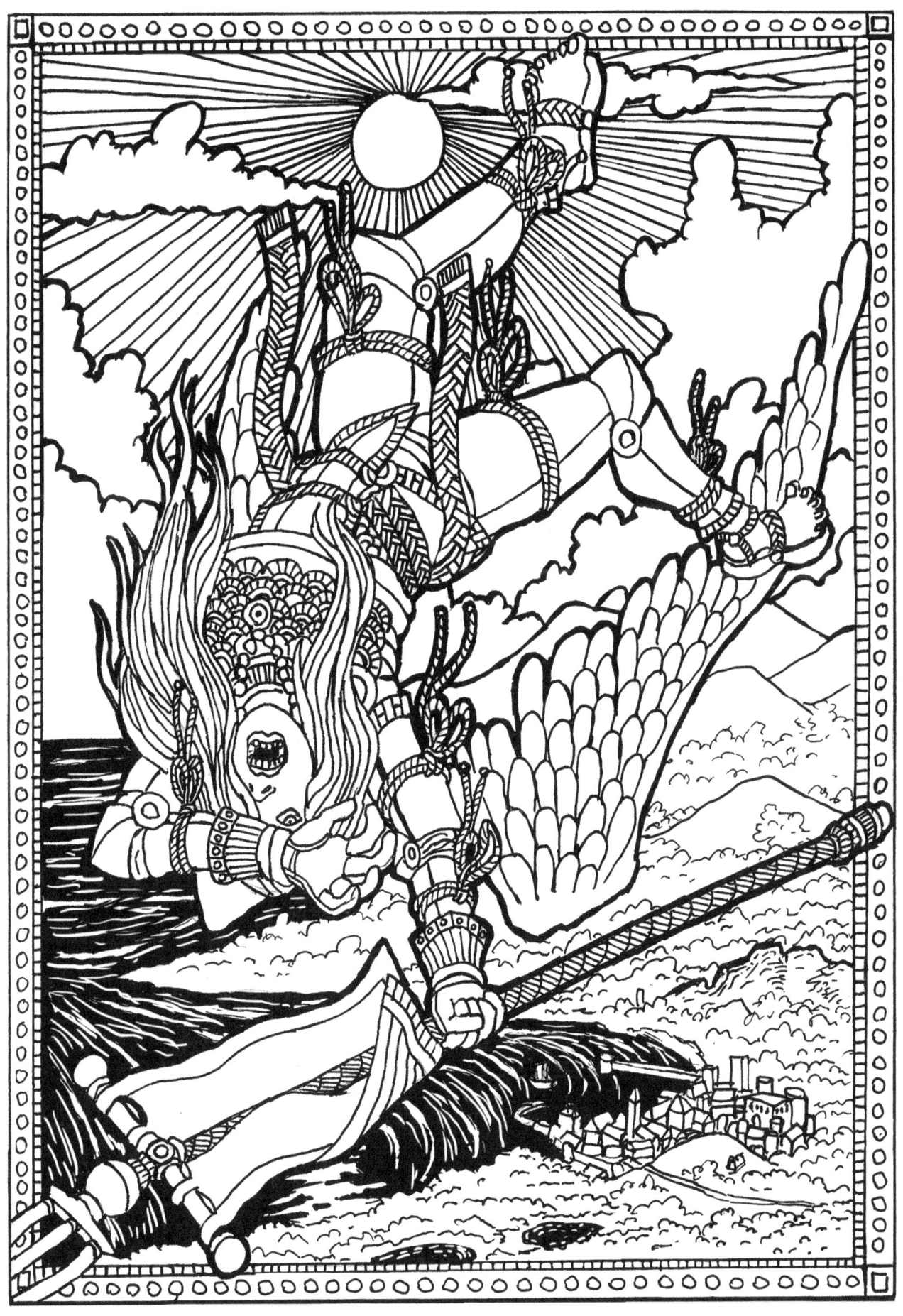

# ① The Fall of Lucifer

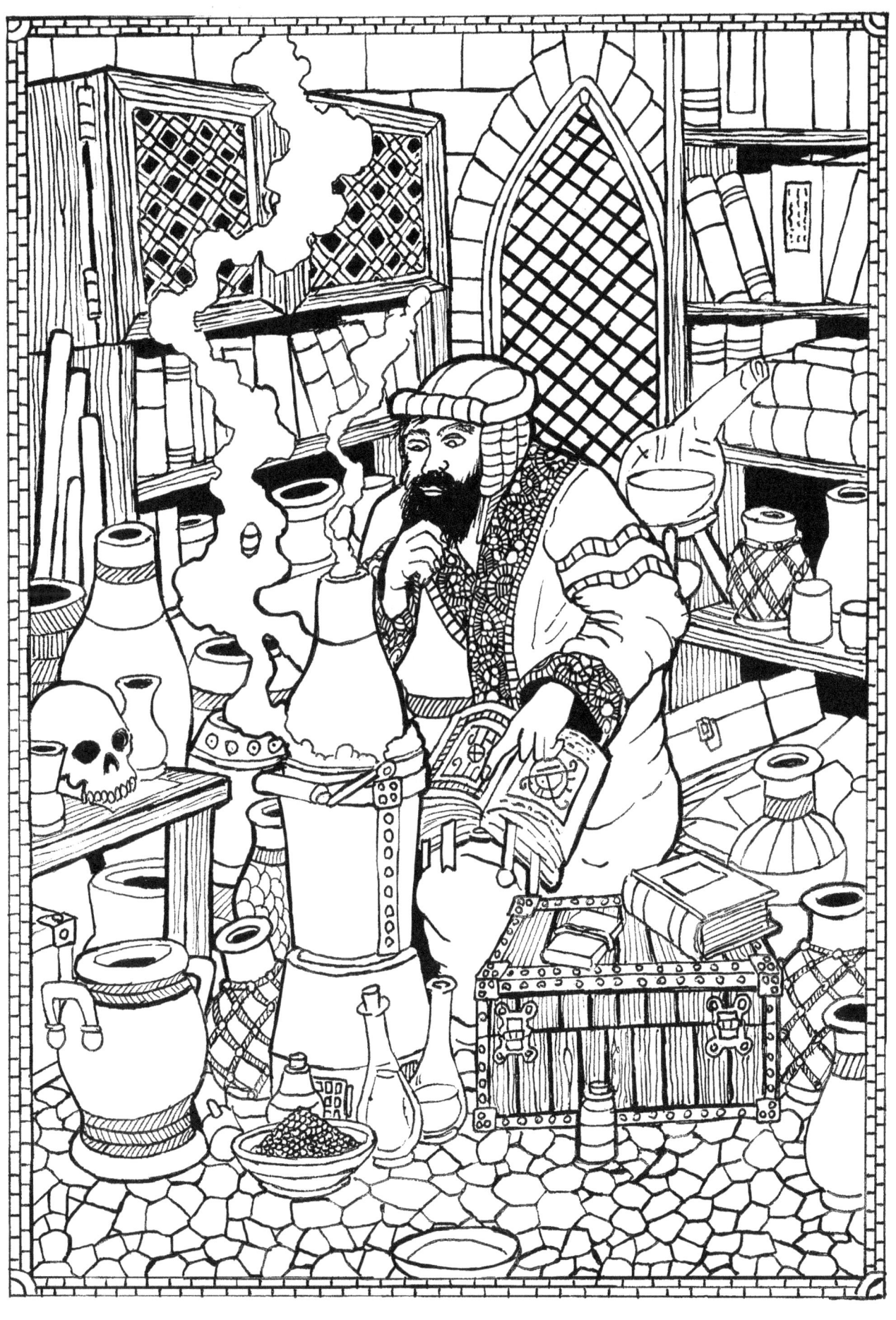

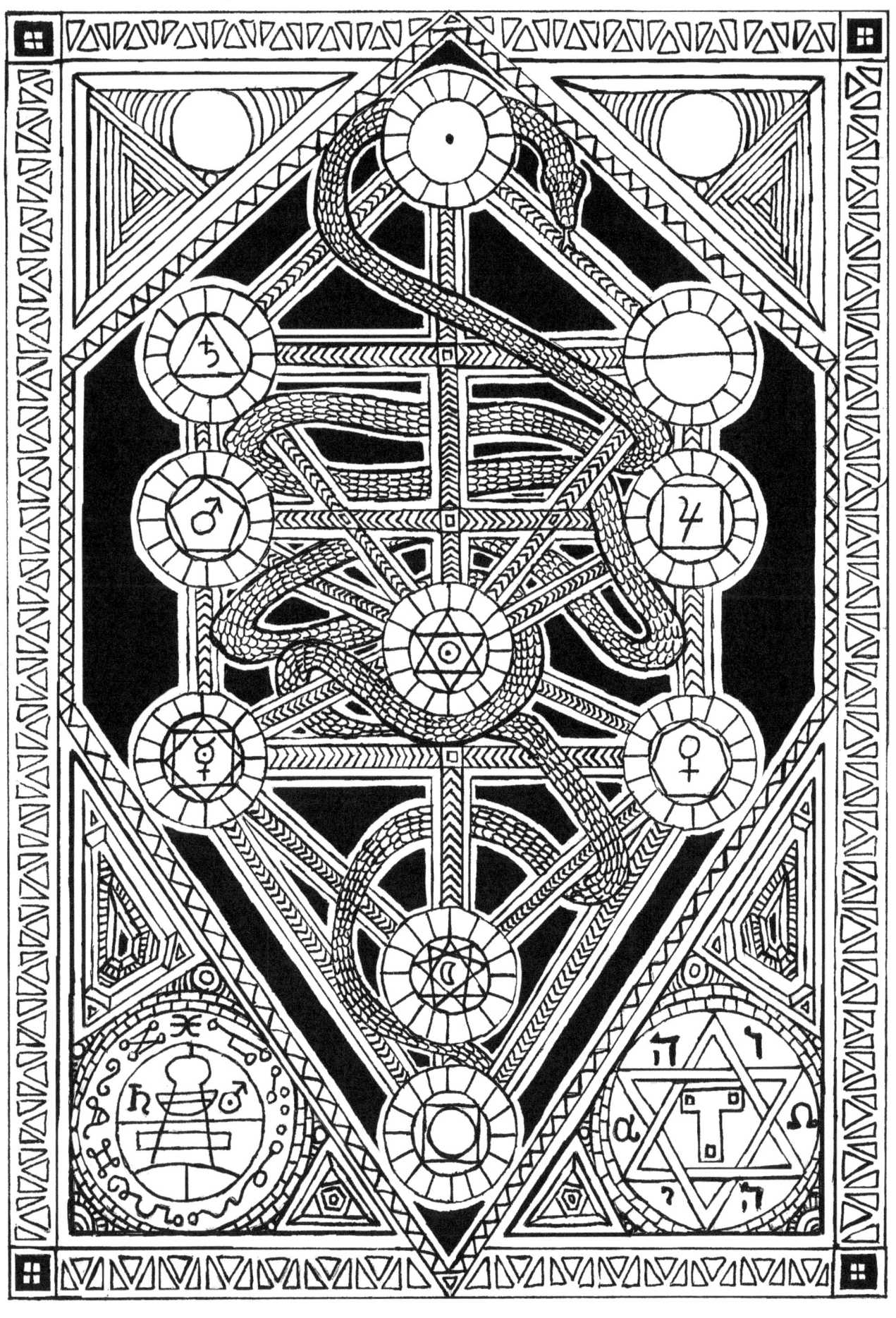

# The Sefirot

③

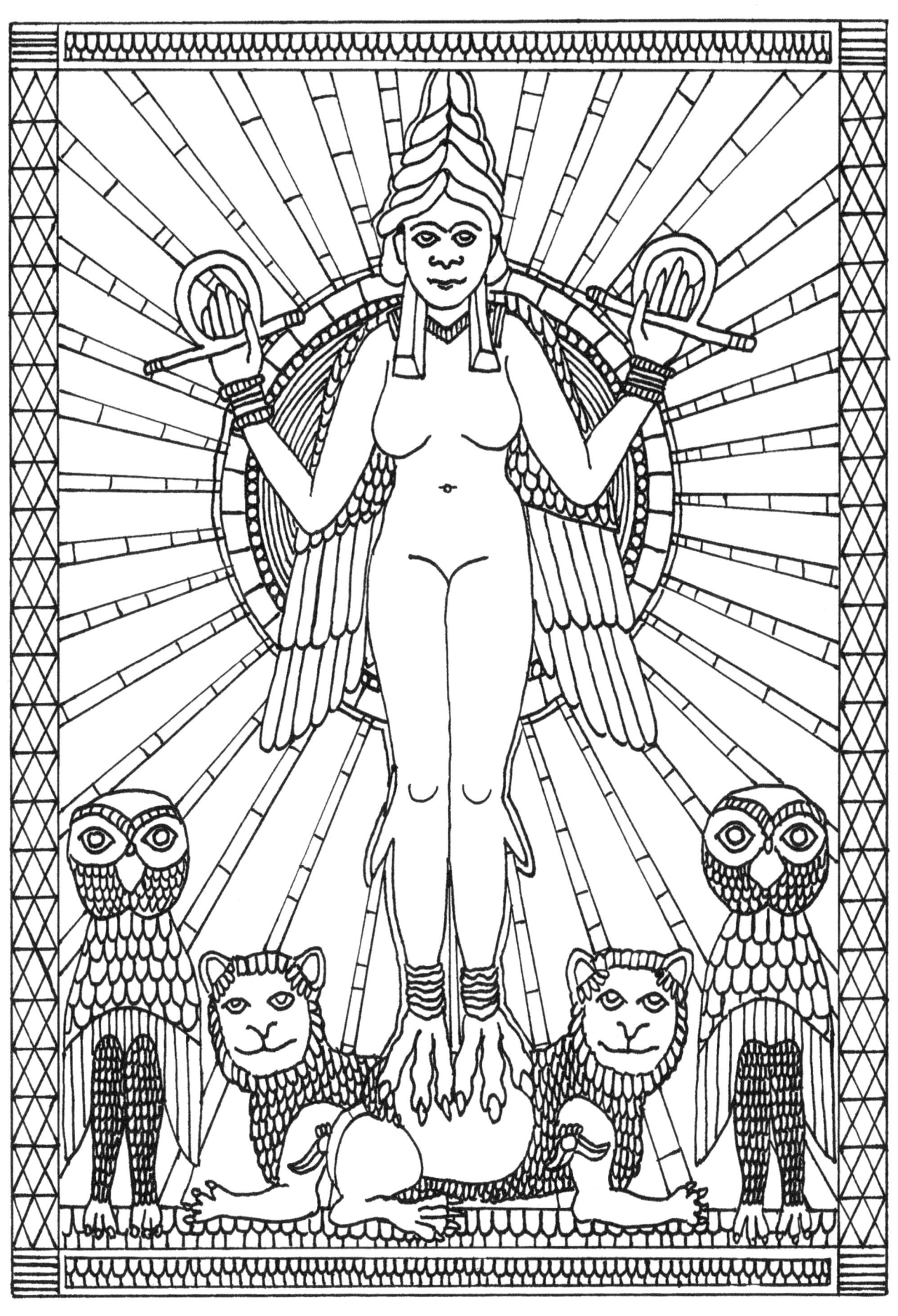

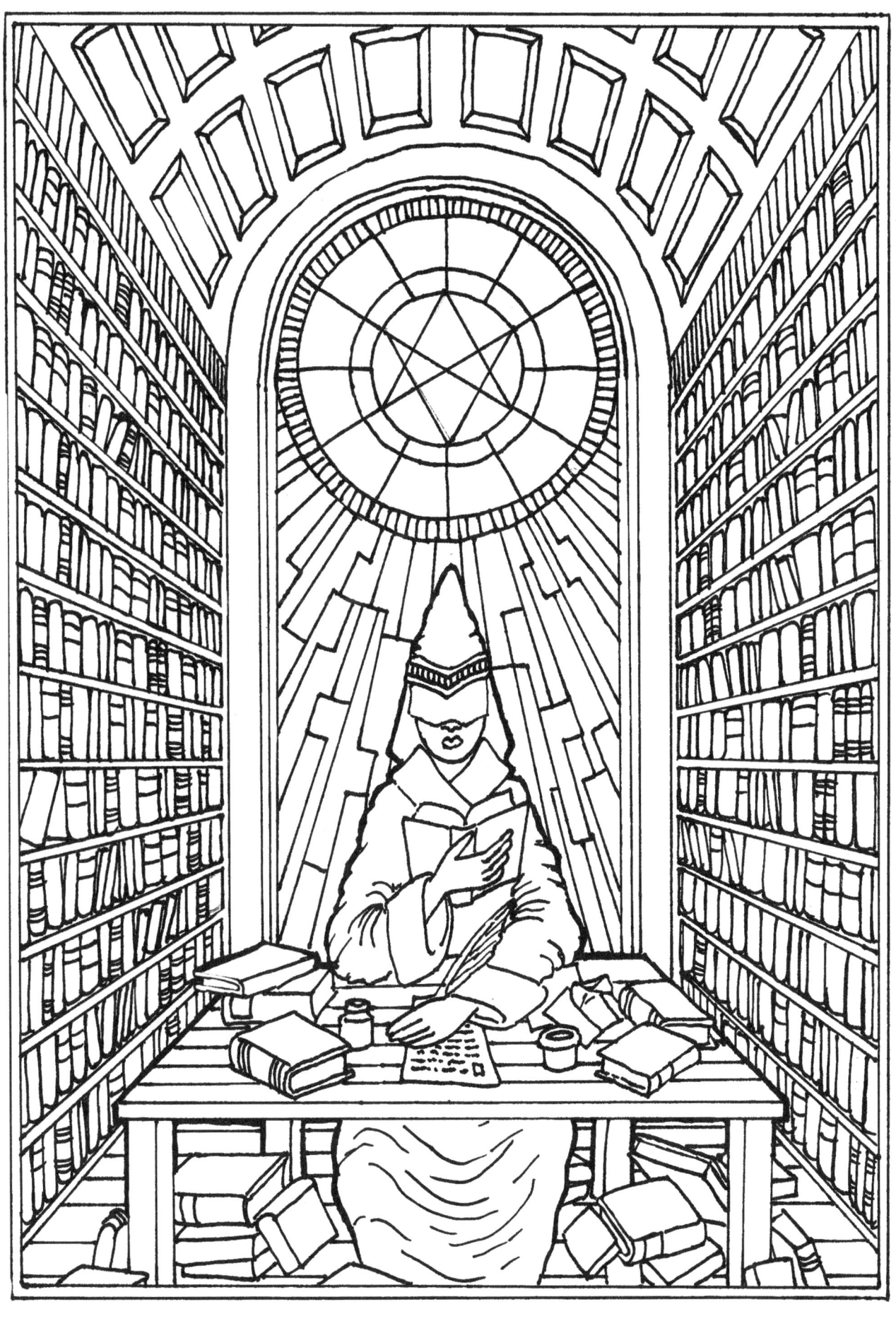

**5** The Heirophant

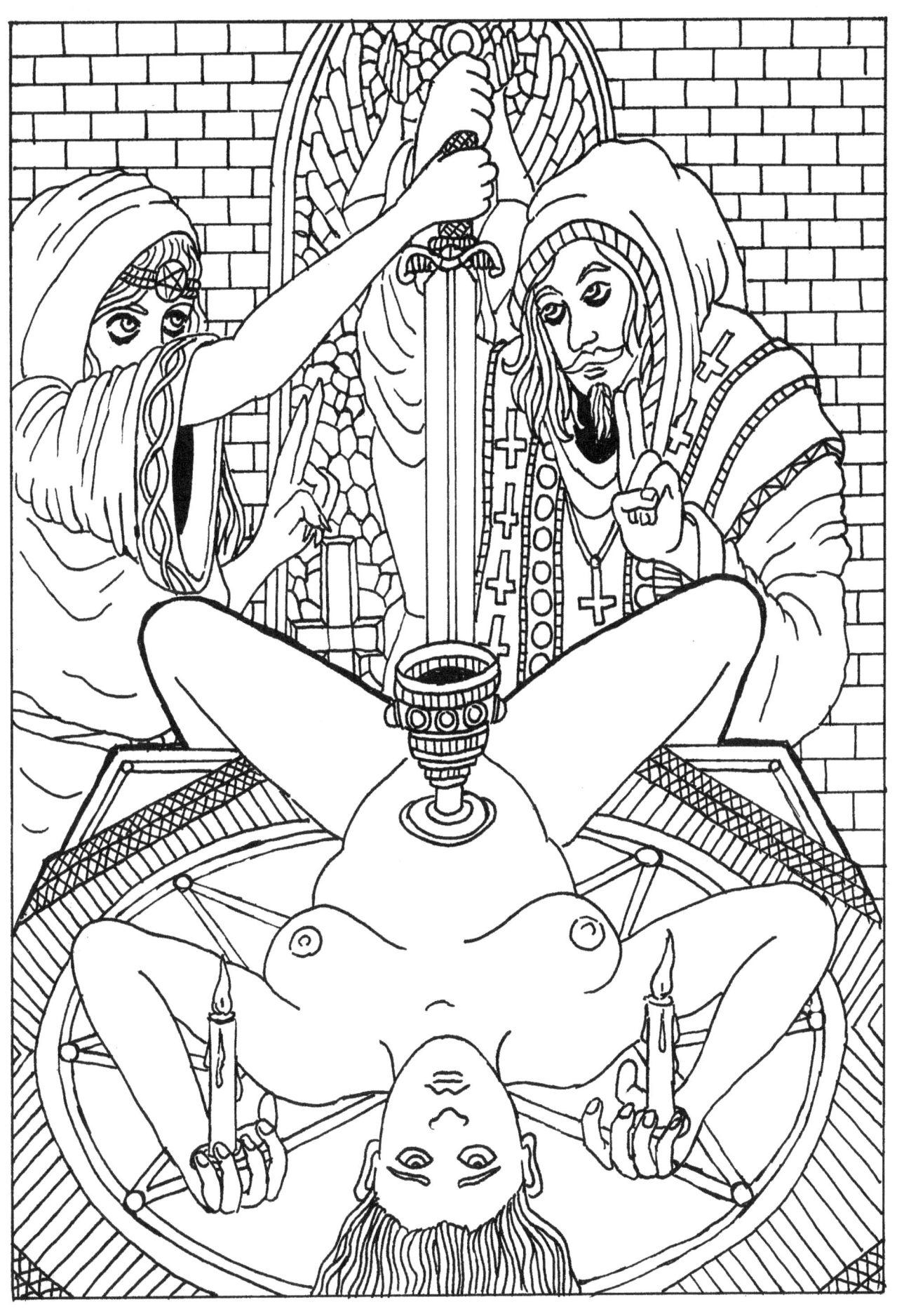

The Black Mass

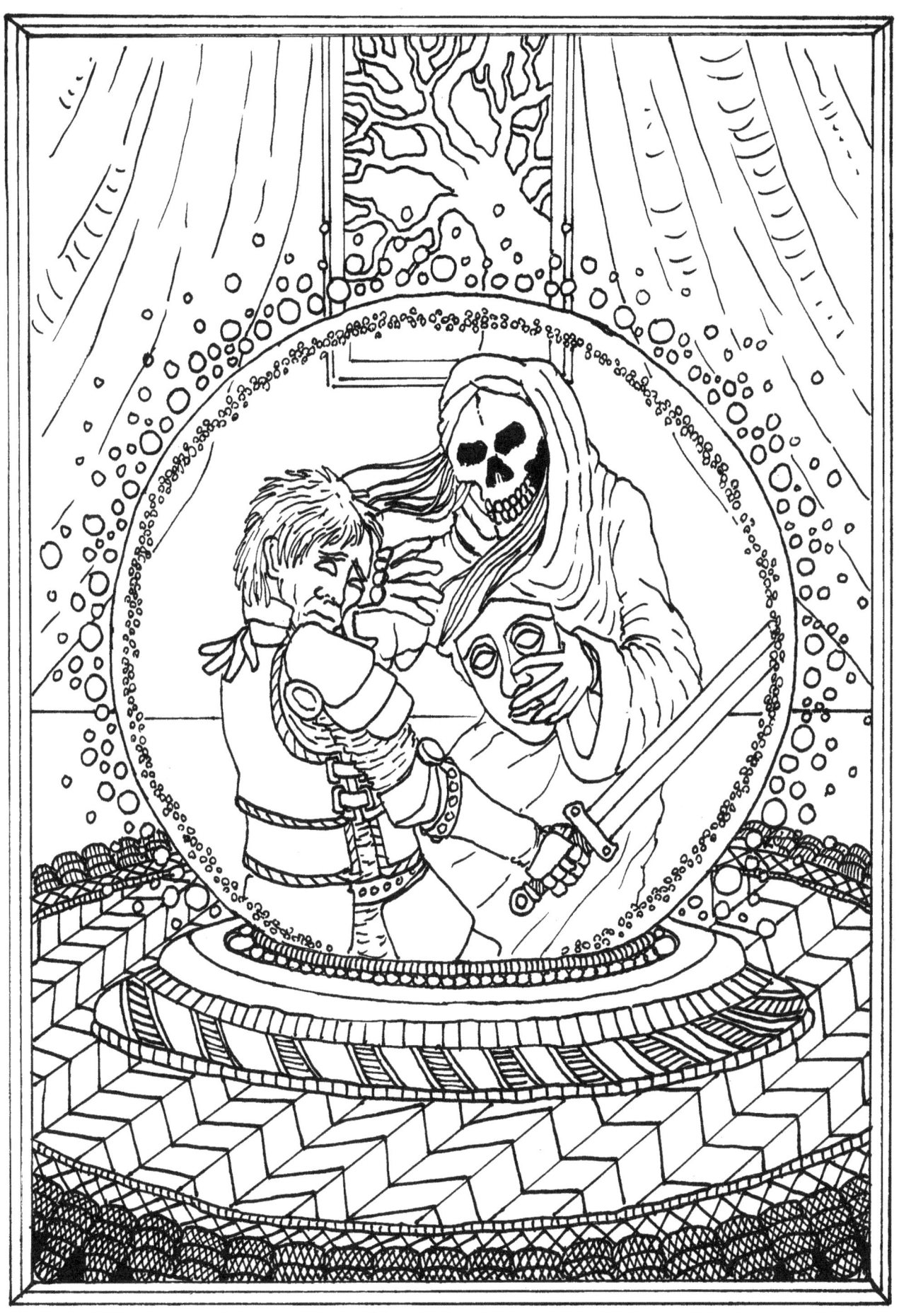

The Orbuculum

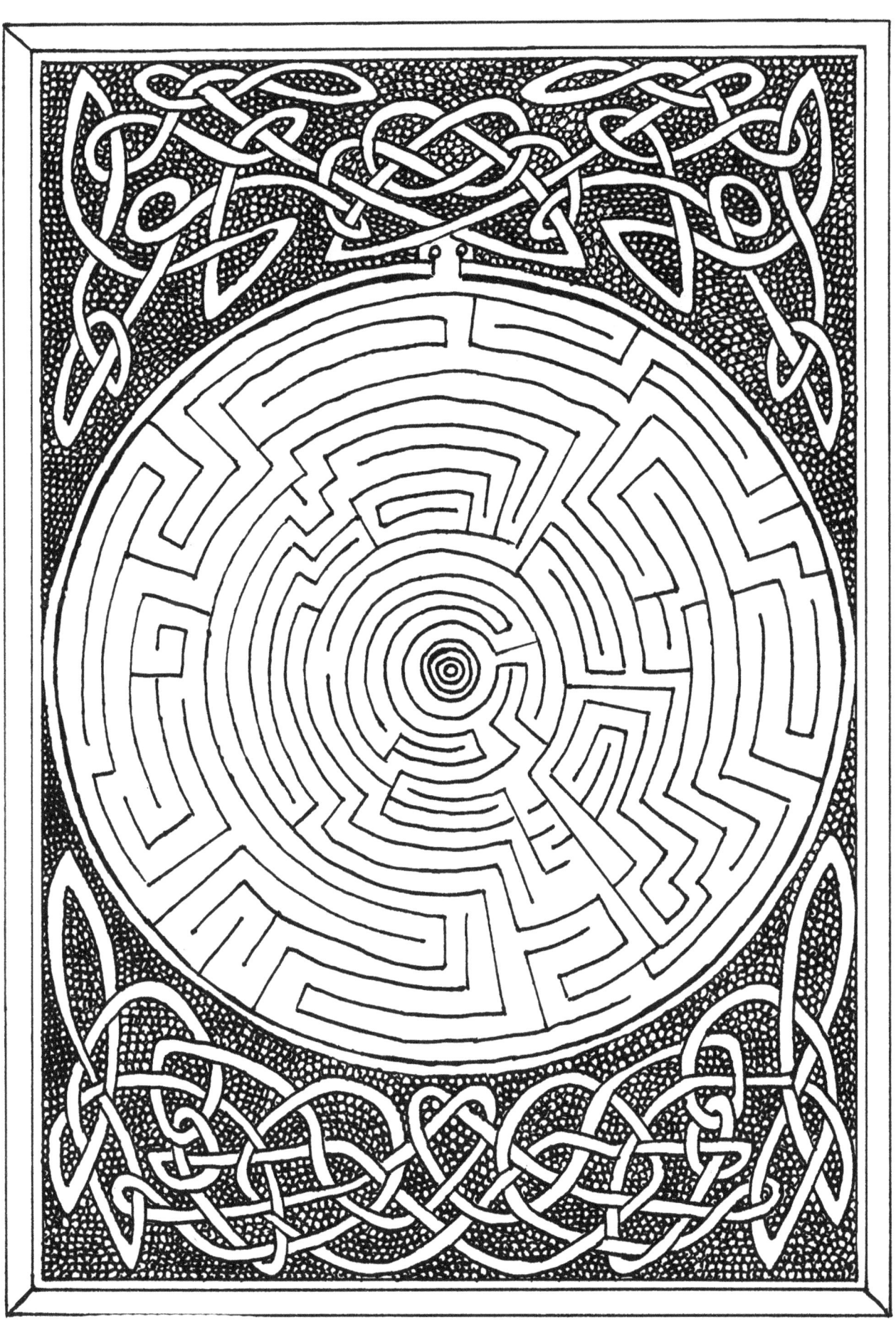

The Labyrinth

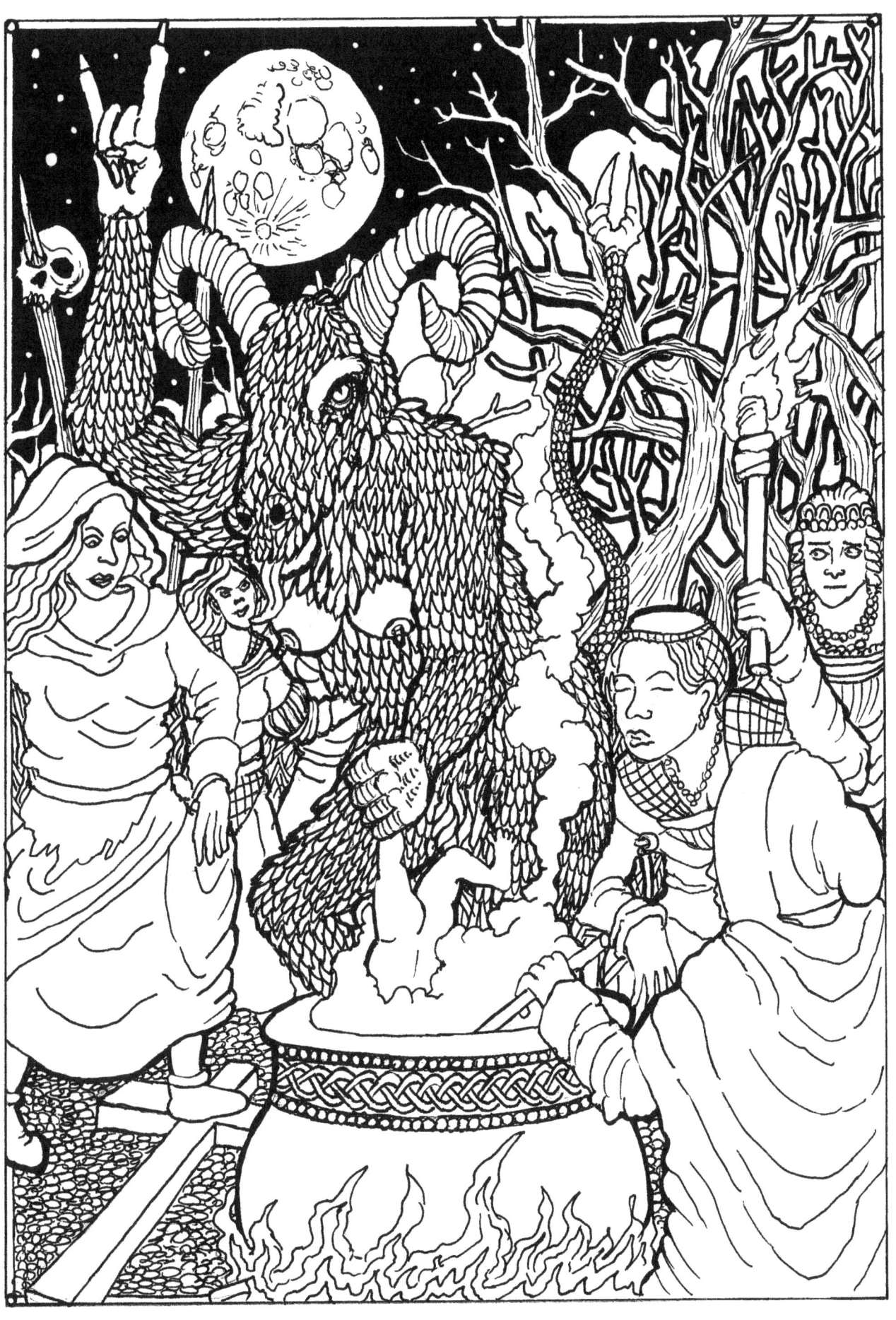

9 The Witch's Sabbath

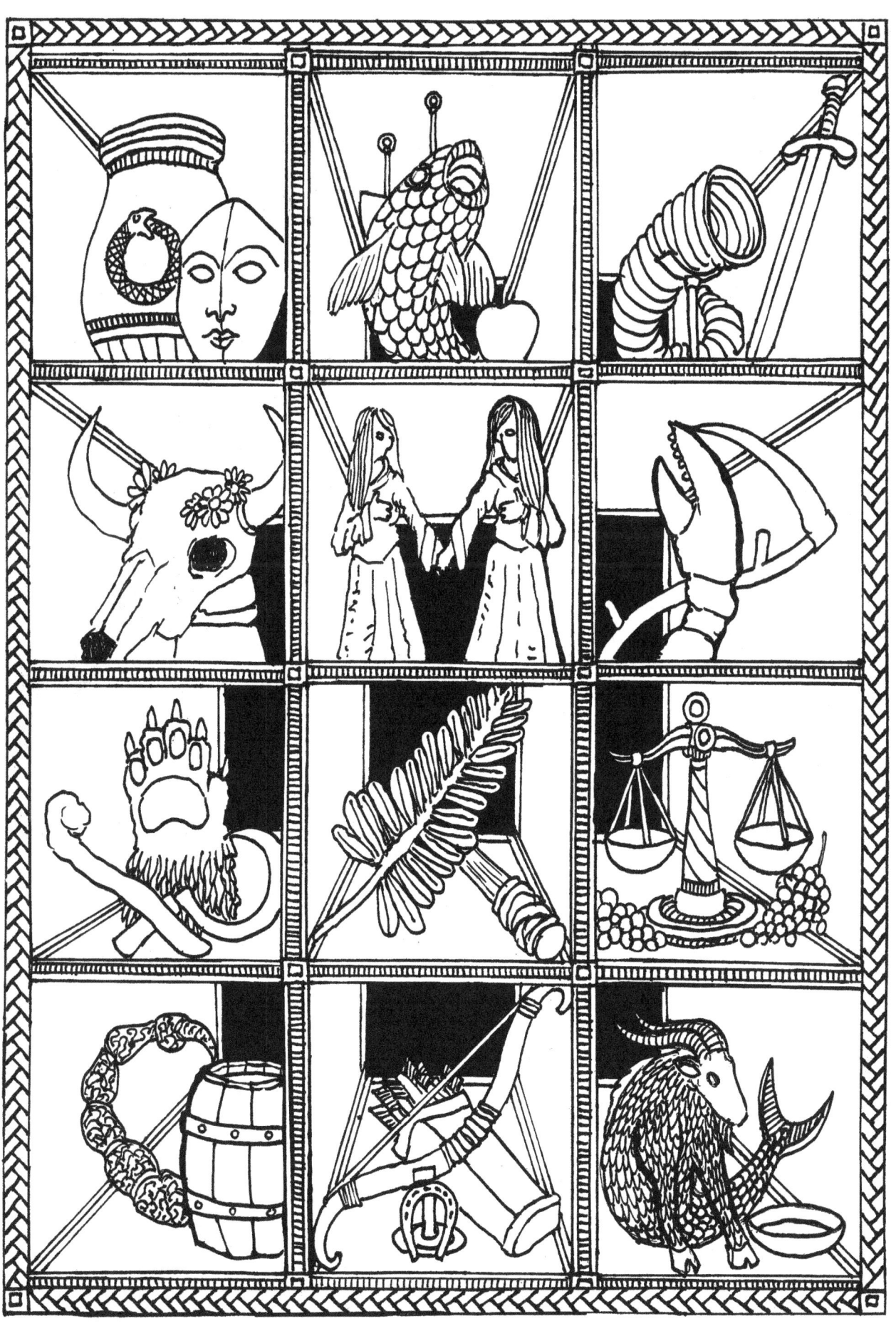

The Houses of the Zodiac

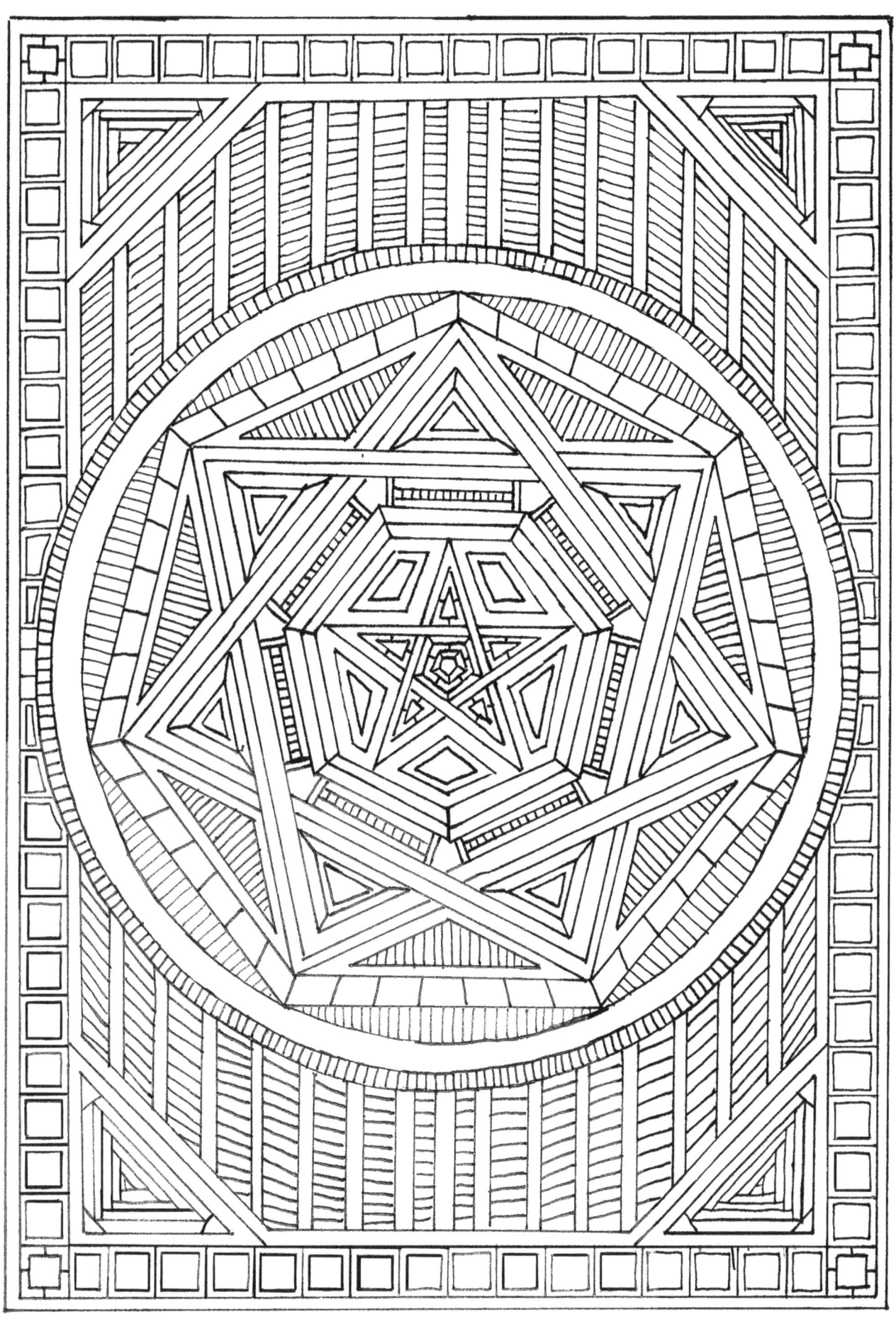

**11** The Great Seal

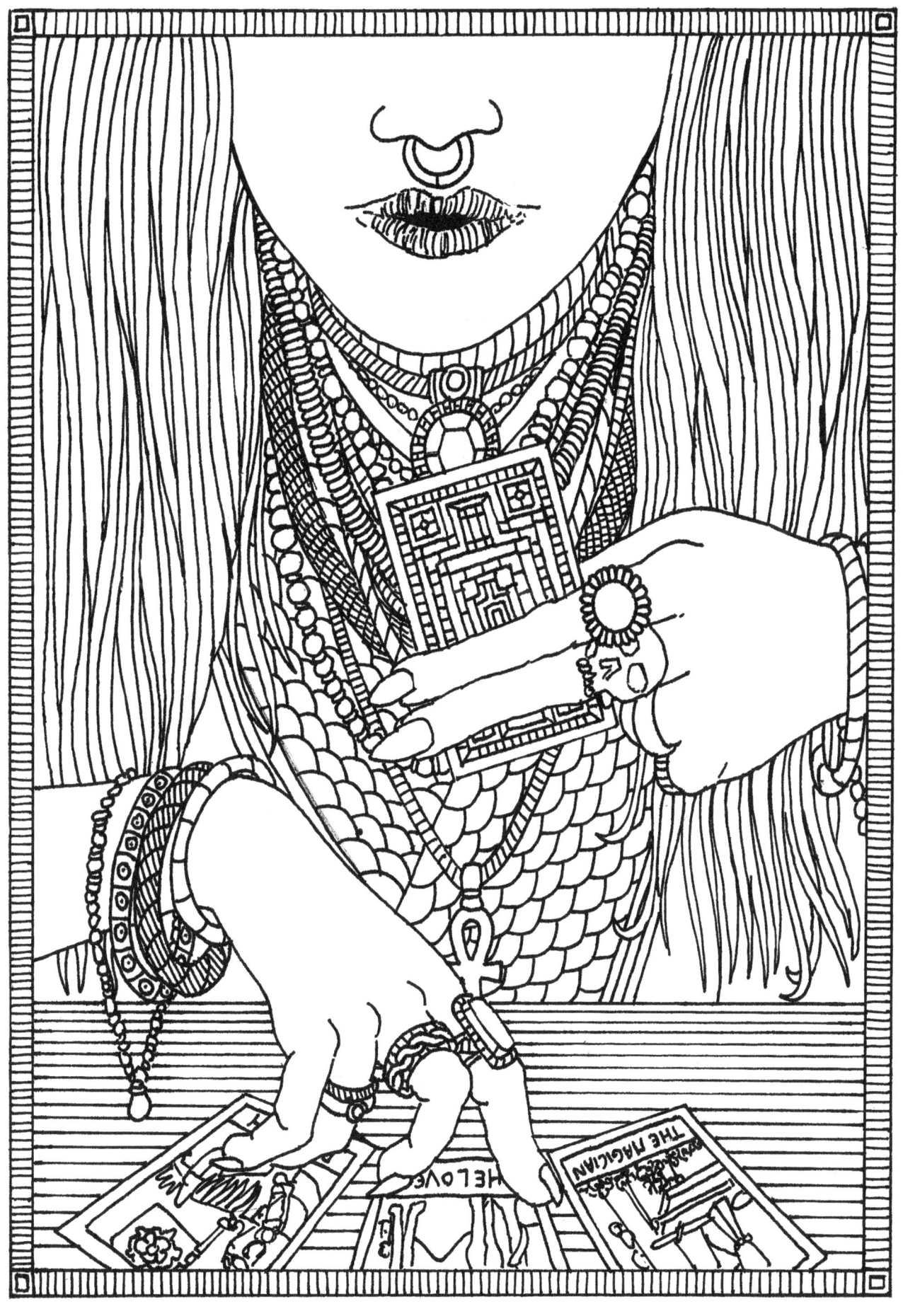

The Tarot Reading

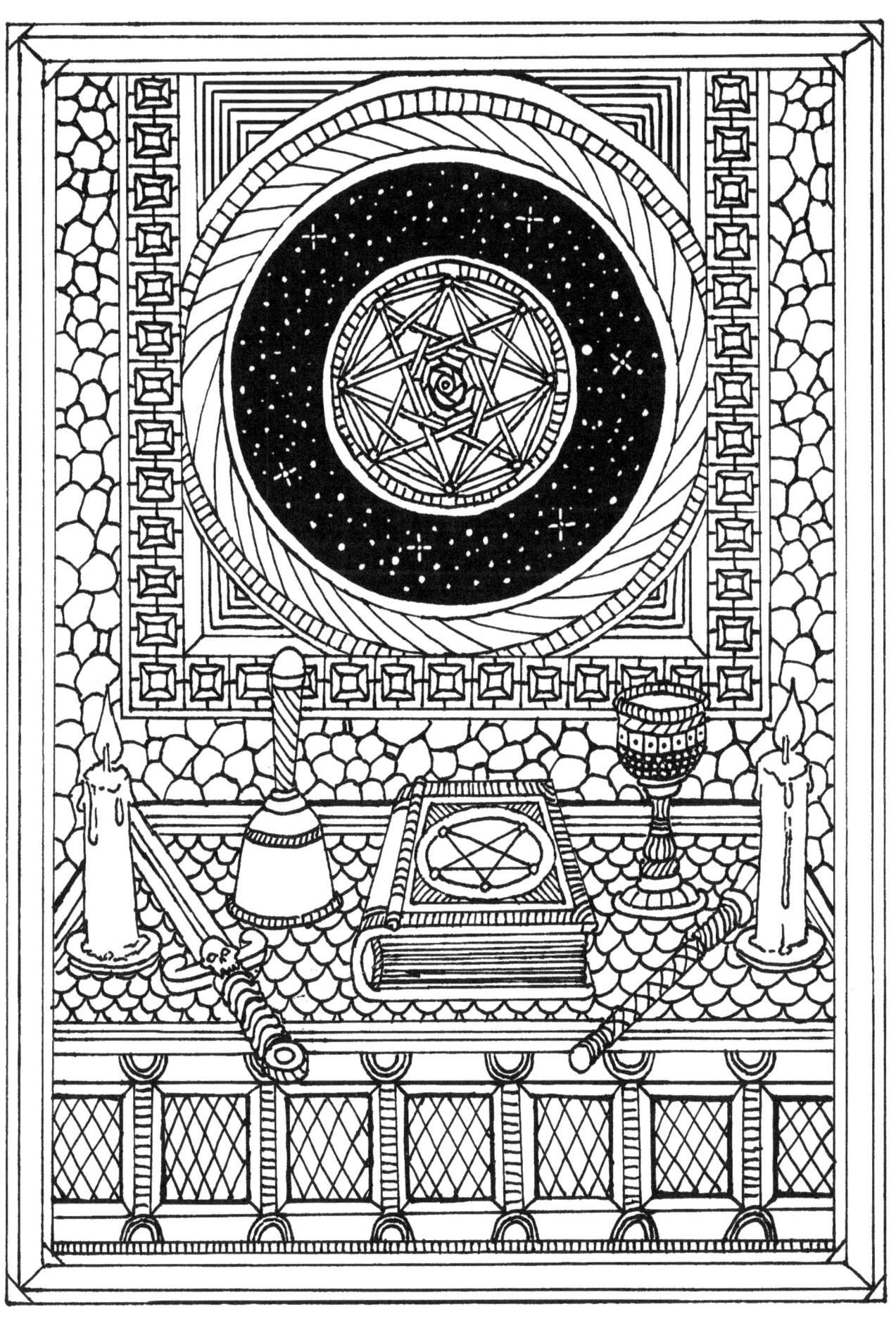

**13** The High Altar

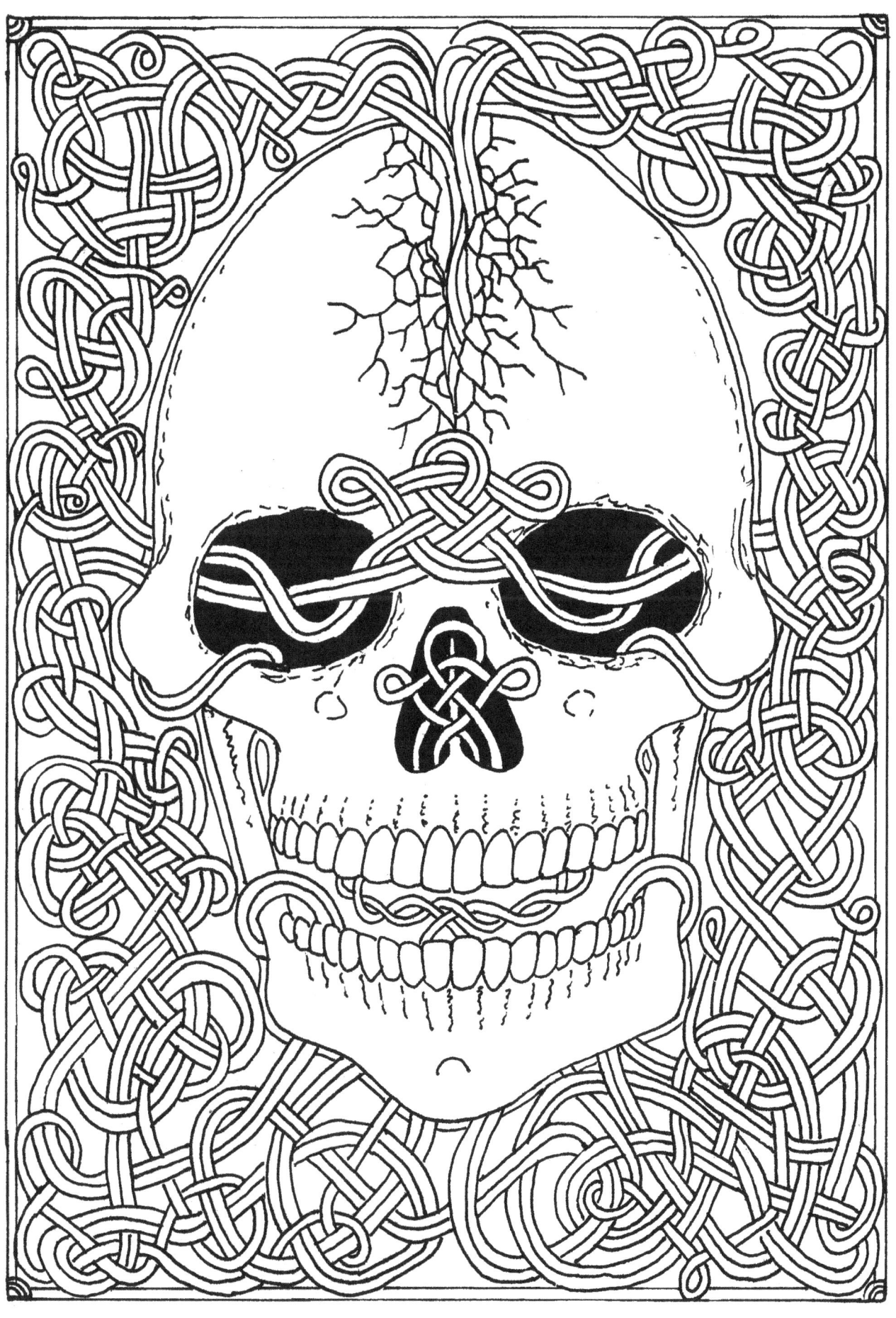

The Endless Knot

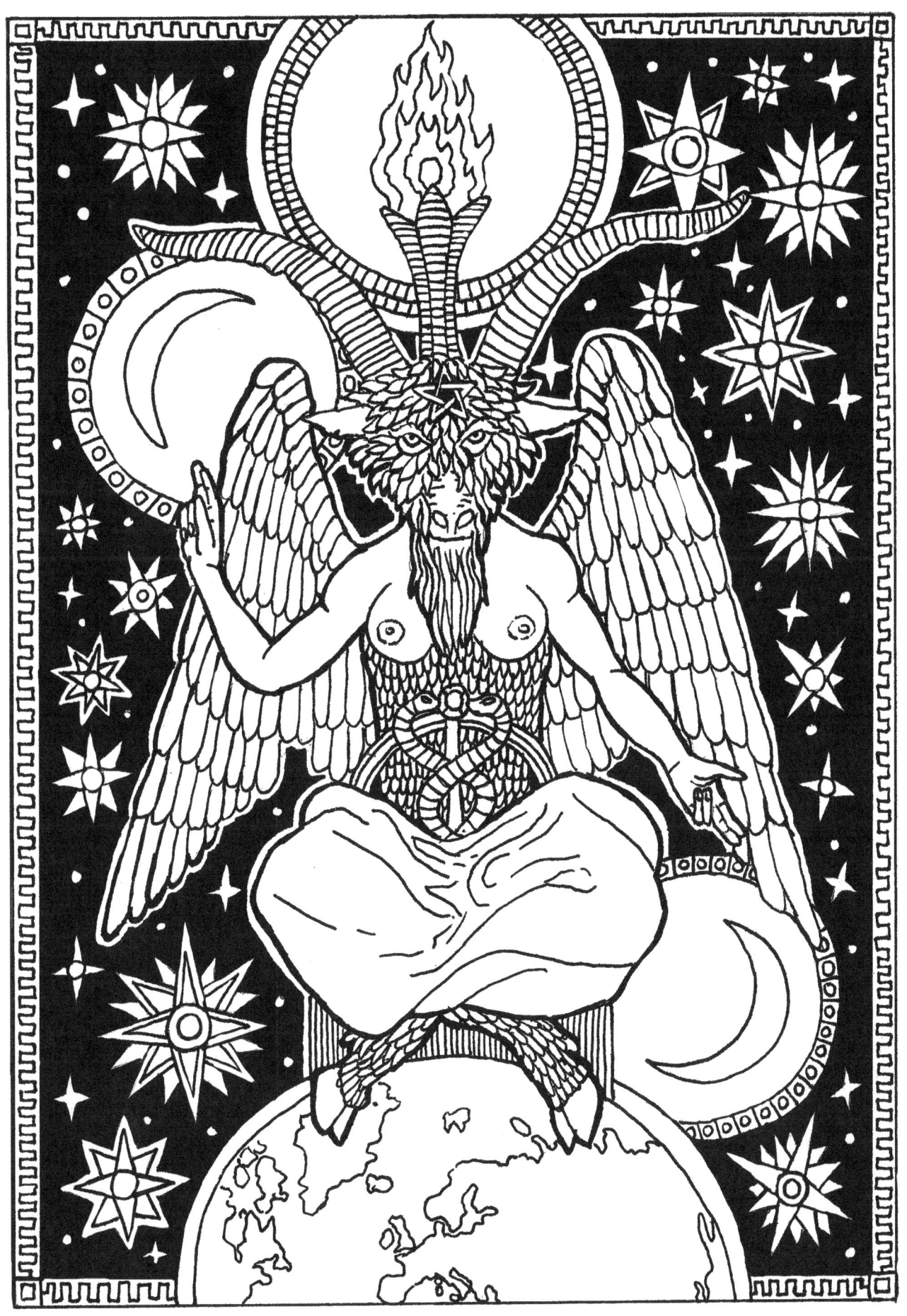

## ⑮ Baphomet

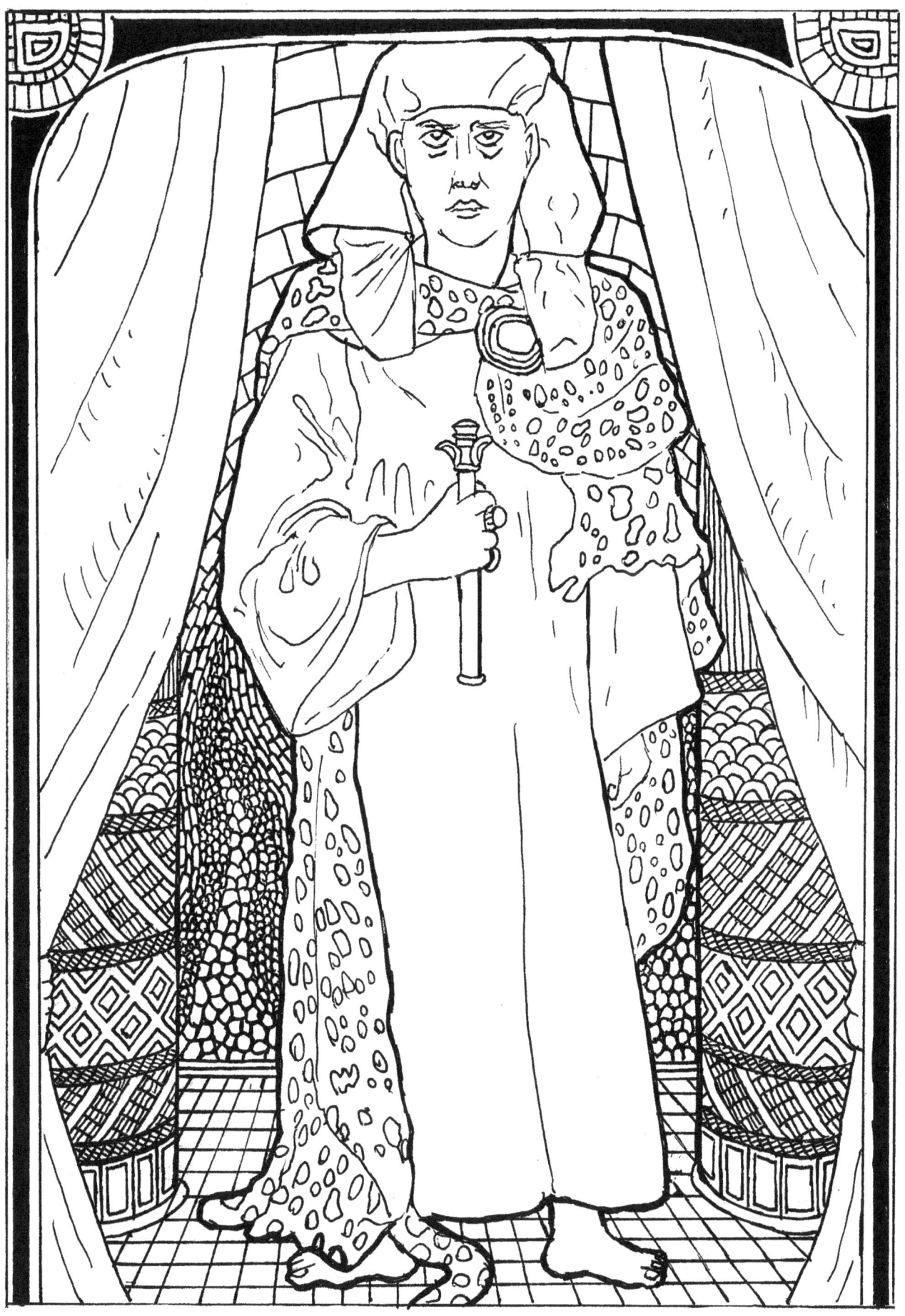

The Magus

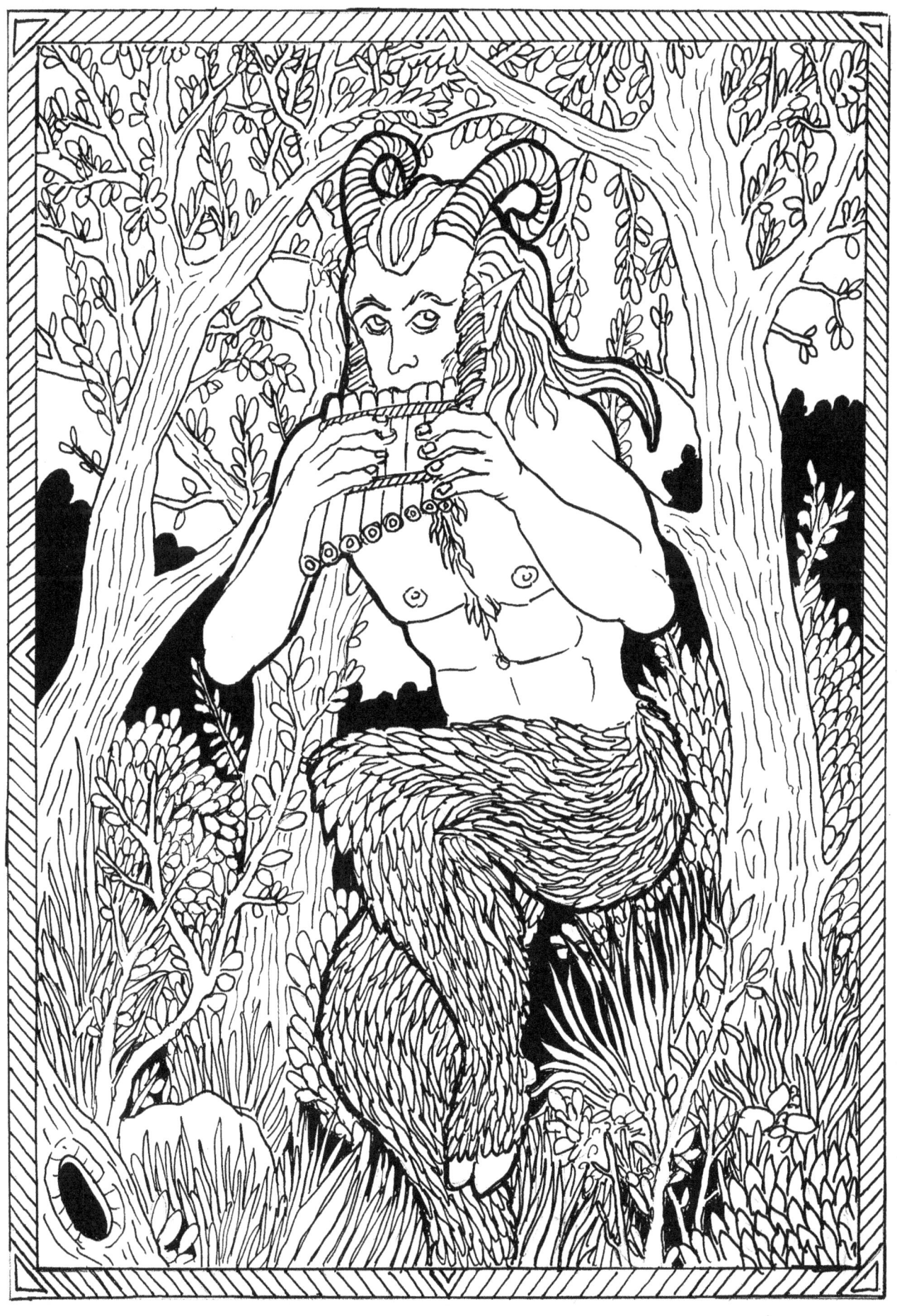

17 The Great God Pan

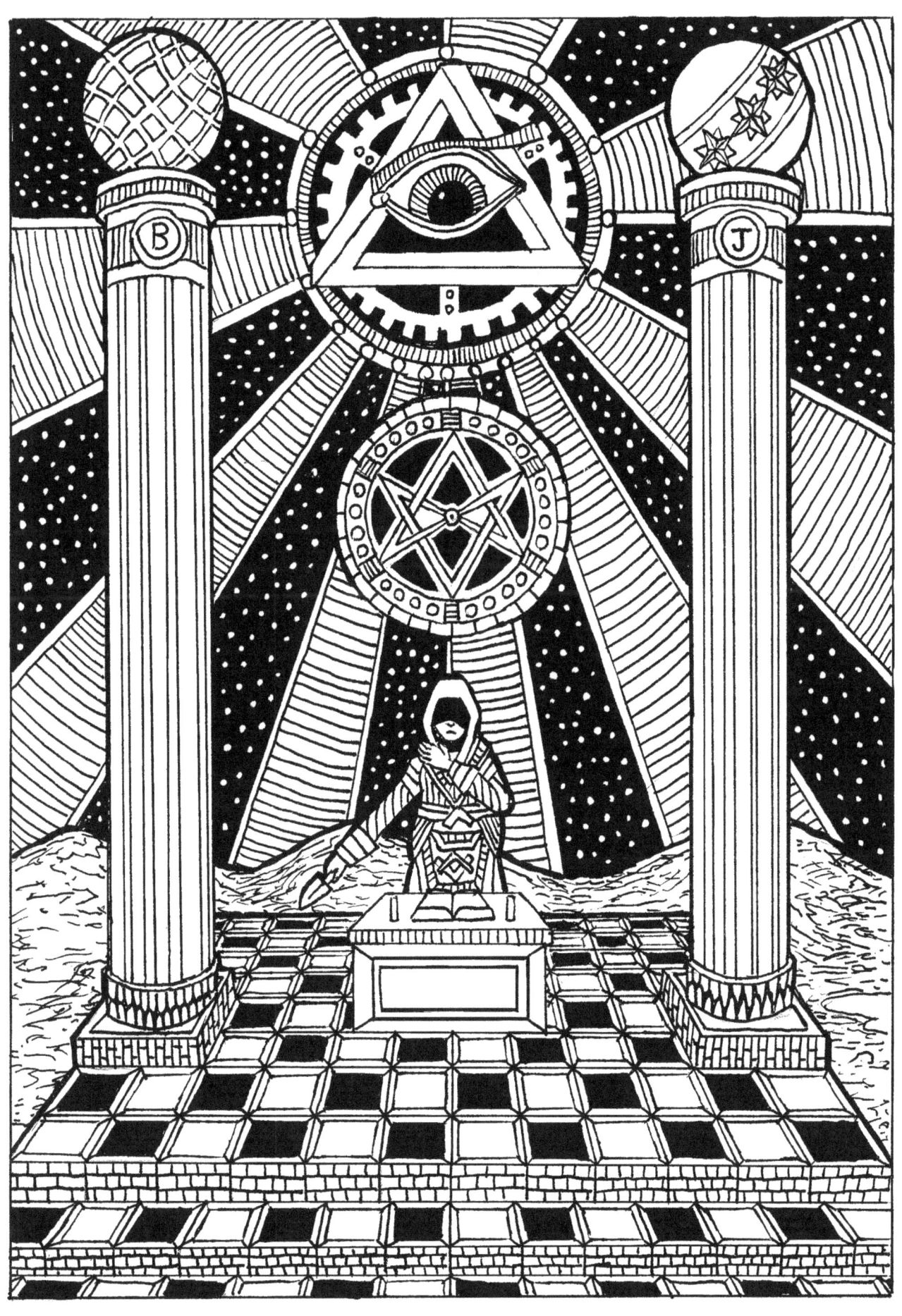

⑱ The Master Mason

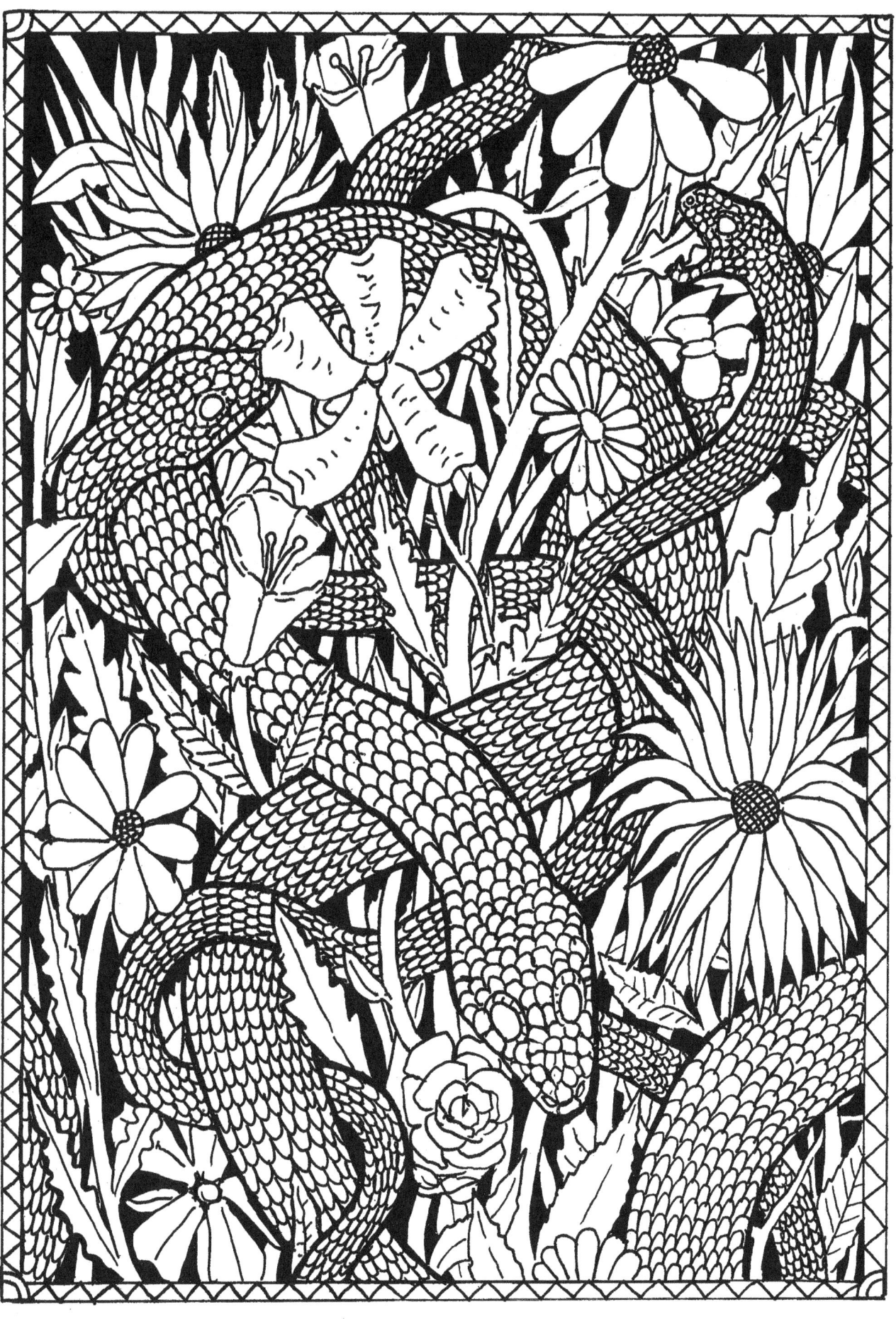

（19）Schlangenkraft

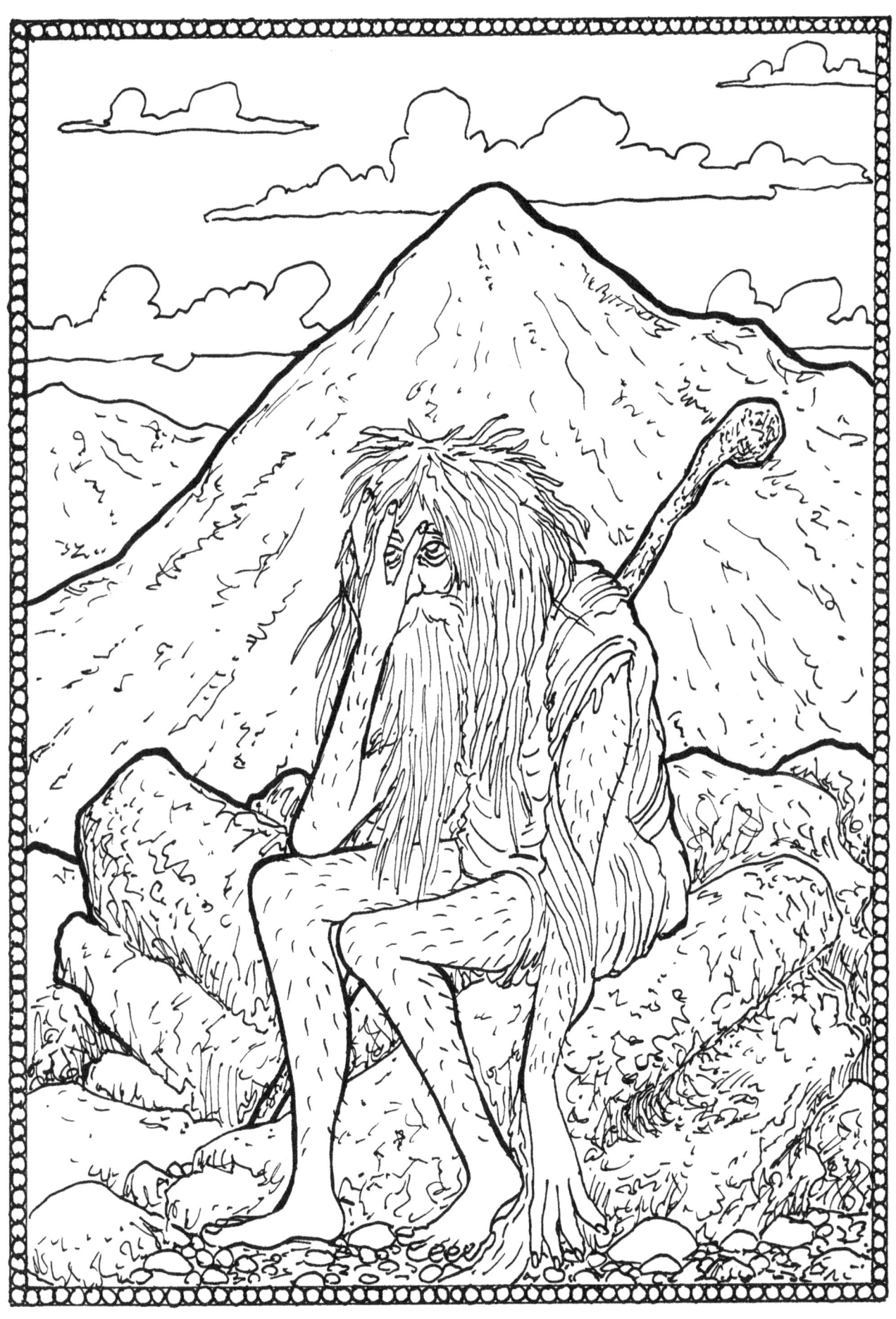

# The Hermit

# Other Titles from Idle Toil Press:

## By DS Blake:
**Illustration and Cartoons**

**The Glimmercage Urists**
*ISBN: 9781291674828*

**Bowel Movements**
*ISBN: 9781326349653*

## By Simon Cardew:
**Artist's Books**

**Exonomnicon**
*ISBN: 9781291341720*

**Manifest-O**
*ISBN: 9781291341683*

**Vectis**
*ISBN: 9781291371314*

**Utopia/Dystopia**
*ISBN: 9781291536034*

**Speak of the Devil**
*ISBN: 9781291680300*

**16 Landscapes**
*ISBN: 9781291893854*

**Physical Remains**
*ISBN: 9781326252137*